PONDER
THESE THINGS

PONDER
THESE THINGS

Praying with Icons
of the Virgin

ROWAN WILLIAMS

SHEED & WARD
Franklin, Wisconsin
Chicago

As an apostolate of the Priests of the Sacred Heart,
a Catholic religious congregation, the mission of
Sheed & Ward is to publish books of contemporary impact
and enduring merit in Catholic Christian thought and action.
The books published, however, reflect the opinions of
their authors and are not meant to represent the official position
of the Priests of the Sacred Heart.

2002

Sheed & Ward
7373 South Lovers Lane Road
Franklin, Wisconsin 53132
1-800-266-5564

Cover design by Leigh Hurlock
Interior design by Vera Brice

Illustrations © see page 75

ISBN 1-58051-124-4

1 2 3 4 5 05 04 03 02

Printed in Singapore

Contents

PONDER
THESE THINGS

Foreword

'Praying with Icons': such is the subtitle that Arch-bishop Rowan Williams has given to this book, and in this phrase he emphasizes the real meaning of the icon. As he fully appreciates, the icon is not simply a work of art on the same level as any other work of art. On the contrary, the icon exists within a specific con-text; and, if divorced from that context, it ceases to be truly itself. The icon is part of an act of worship; its context is invocation and doxology. The art of the icon is a liturgical art. In the tradition of the Orthodox Church, the icon is not merely a piece of decoration or a visual aid. We do more than just look at icons or talk about them; we *pray* with them. In fresh and unex-pected ways this book indicates how this can be done.

It is not so much a study of the icon as an invitation to prayer.

The icon reveals to us what Archbishop Rowan terms 'the utter strangeness of God', but it also shows us God's closeness, his total involvement, his vulnerability. In the world but not of it, the icon bears witness to the nearness yet otherness of the Eternal. It introduces us to a world of mystery, yet at the same time we discover that this mystery is not far away, but is hidden within each one of us, closer to us than our own heart.

The icon has been described as 'theology in line and colour'. Archbishop Rowan for his part attaches particular importance to the lines of each icon, to the movement and the sense of direction that it expresses – to the direction in which the hands are pointing and the eyes are gazing. In discussing the different icons of the Virgin and Child, he shows how through the gestures of the hands and the orientation of the eyes each icon brings before us not isolated figures but persons in relationship. Moreover, into this interpersonal

relationship we the worshippers are also drawn. The movement within the icon, the pattern of love that it discloses, embraces us as well. We are not just spectators, but we become actors in the scene that we see before us. The icon enfolds us; contemplation becomes participation.

Icons, says Archbishop Rowan, show us the way; they invite us to follow a journey, to engage in a pilgrimage. They help us to cross borders, to enter into a new and transfigured world. And that is exactly what I experienced as I read this book; I felt indeed that I was crossing borders in the author's company. Speaking of icons thoroughly familiar to me, he succeeded in revealing within them spiritual meanings of which I had never been previously aware. He possesses to an unusual degree the gift of creative imagination. He also has the ability to express profound truths in a very few words. This is a book to be read not once only but many times.

Kallistos Ware
Bishop of Diokleia

Introduction

What follows is based on material used for meditations during one of our annual diocesan pilgrimages to Walsingham, in Norfolk, 'England's Nazareth'. It invites pilgrims to think about some of the different ways in which Mary is regularly portrayed in the art of Eastern Christianity, so as to think in turn about what it is in a pilgrimage to come to a new frontier in your relation with God. People go on pilgrimage to places like Walsingham — as it is often said — because of the sense that there they are approaching, perhaps even crossing, a boundary. There is a new landscape hinted at, inviting you to come and begin to inhabit it. But the invitation is at the same time a disorienting and frightening one, requiring a loss and a risk. Eliot

writes, famously, in *Little Gidding* about letting go of 'what you thought you came for', and goes on to note that, as well as Little Gidding, 'There are other places/Which are also the world's end.' Pilgrimage is always going to be towards that 'world's end' that is still somehow within the world, to the place where (using the language of the Hebrew Scriptures) God has decided to make his name dwell.

What we call holy in the world — a person, a place, a set of words or pictures — is so because it is a transitional place, a borderland, where the completely foreign is brought together with the familiar. Here is somewhere that looks as if it belongs within the world we are at home in, but in fact it leads directly into strangeness. C. S. Lewis's wonderfully prosaic images of wardrobe and lamp-post as markers of the frontier between us and Narnia are simply one more instance, so effective because so incongruous. And what I have

tried to do in these reflections is to think about three different kinds of borderland holiness. In the background, not much discussed, there is the place itself where these talks were given, a place that still attracts and confronts people, for all that it can be also a focus of churchy controversy or a theme park of rather over-the-top devotion. There is the reality of the icon, which is a picture of some bit of this world, so depicted and so constructed as to open the world to the 'energy' of God at work in what is being shown. And, most importantly, there is the person who stands on the frontier between promise and fulfilment, between earth and heaven, between the two Testaments: Mary. That she can be represented in so many ways, thought about and imagined in so many forms, is an indication of how deeply she speaks to us about the hope for the world's transfiguration through Jesus; how she stands for the making strange of what is familiar and the homeliness of what is strange. After all, it is she who literally makes a home for the

Creator of all things, the strangest reality we can conceive, in her own body and in her own house, she whom we meet again and again in the Gospels struggling with the strangeness of her son, from the finding in the Temple to the station at the cross.

As I have said, there are so many ways of representing her. A full catalogue of the conventions of Orthodox iconography in respect of depicting Mary would be a long study in itself. And although scholars of icon-painting are inclined to look down on those who oversimplify these conventions, I am going to concentrate on three of the commonest 'families' of representations, well aware that each of the three has countless variants across Orthodox history and geography. Those who know the material better will have to be patient with these reflections, patient too with the fact that I have sometimes used details that are not universally present in the icons to draw out a

point. All I have tried to do with regard to these images is to seek ways that will help us 'read' what the icon 'writes', whether it is written deliberately or by God's providence.

These meditations are really about how we are led by faith both to live in the world, fully flesh and blood in it, and at the same time to be aware of the utter strangeness of God that waits in the heart of what is familiar — as if the world were always on the edge of some total revolution, pregnant with a different kind of life, and we were always trying to catch the blinding momentary light of its changing. That is what any icon sets out to embody and transmit. We, watching and waiting for Christ to come more fully to birth in us, are waiting for our lives to become 'iconic', to show in their colour and line and movement how God acts, Christlike, in us.

The One
Who Points the Way

THE *HODEGETRIA*

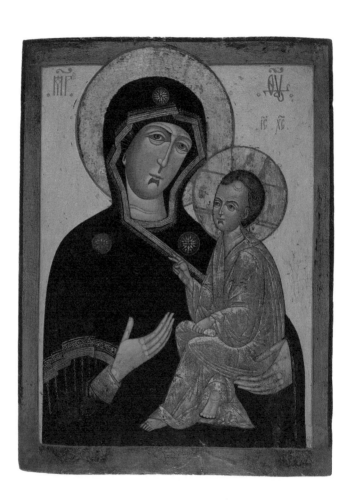

The *Hodegetria*, she who shows the way, is one of the many styles of depicting the Mother of God that originated in the early Middle Ages. It is a very simple representation: the child Christ sits cradled by his mother's left arm while she points to him with her right. In most versions, his eyes are on her, and he sometimes has a hand raised in blessing.

One of the most significant features of icons is the direction in which the eyes are drawn by gestures and lines. Thus, in the great Trinity icon of Andrei Rublev, the inclination of the heads and the (very muted)

gestures of the hands tell us a great deal about what Rublev is saying — what he is 'writing', since Orthodox Christians speak of the 'writing', not the painting, of an icon — about the relations of the divine persons. In that sense, all icons 'show a way'; they invite us to follow a line, a kind of little journey, in the picture. It is not, of course, a peculiarity of icons: there are plenty of great Western images that require something similar, most powerfully, perhaps, the Isenheim altar piece of Grünewald, with John the Baptist's immensely elongated forefinger pointing towards the crucified. But in the icon, we are not talking about dramatic gestures that underline a point, but rather about the journey the eye has to take *around* the entire complex image: wherever you start, you are guided by a flow of lines, and the path travelled itself makes the 'point' — though 'point' is quite the wrong word, suggesting as it does that the icon has one simple message to get across, rather than being an invitation to a continuing action of contemplating.

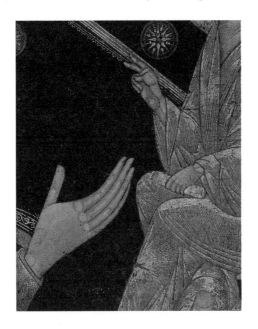

So the *Hodegetria* pivots about the gesture of the Virgin towards the child, but does not stop there. Christ's eyes take us to Mary's face; Mary's eyes are turned to

us, as so often in these images. She addresses us with her eyes; and what she has to say to us is articulated by her right hand. She is introducing her son; but the child she shows to us is precisely a figure who gives his whole attention to her. It is very typical of the icon style that it presents people to us clearly in defining relations to each other, not as solitary portraits. And it

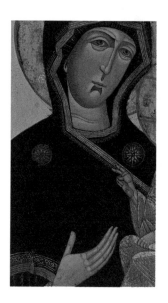

is not only that we cannot understand Mary without seeing her as pointing to Christ: we cannot understand Christ without seeing his attention to Mary. Jesus does not appear to us a solitary monarch, enthroned afar off, but as someone whose being and loving is always *engaged*, already directed towards humanity.

In this icon, Mary is who she is by pointing away from herself: her identity is caught up in leading us to Jesus. She is 'the one who points the way' in several senses, therefore. The way to life is the path away from self-contemplation and self-presentation, from putting oneself before the world as an isolated unit, a solid lump of human material, sufficient to itself. More specifically, it is a path towards Jesus; but, in turn, not towards a Jesus who is himself an isolated figure, but towards his loving attention directed towards someone else — just as, in the Rublev 'Trinity', our eyes are

drawn to the central figure (usually thought to be the Second Person, the Word) only to be drawn *by* his posture and gesture towards the left-hand figure (generally identified as the Father). The way to Jesus and with Jesus is the way into his own self-forgetting engagement with the human world, not simply a contemplating of him as a divine individual.

The icon is beginning, then, to say something rather substantial about our knowledge of Christ. We are led to Christ as the one who himself leads to others, who will not appear to us except as one whose love is active and directed. To love Christ is to love his love, and to love what he loves — a point you find expressed with force and imagination by St Augustine in his meditations on the Trinity. And there is another obvious 'Augustinian' implication to be uncovered here, one which the icon makes perfectly plain; for what we see

is, of course, a circular motion, Mary pointing to Christ who looks at her. Mary 'returns' to herself through Christ; she is who she is not only as pointing to Christ but as the object of her son's love; and for her to look to Christ is for her to look at herself truthfully — as loved by him.

So she looks at us, urging us by her gesture *not* to keep our eyes on her face but to follow the hand that points to Jesus; he looks at her, drawing us back to her face;

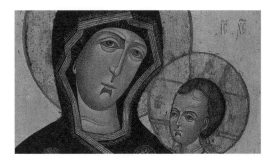

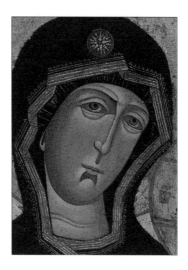

and the face that is the object of Christ's loving gaze is precisely the face that looks not to him but to us, eager for our looking to be turned, converted, to *him*. The path is one where everything is in movement, where our gaze is always being shifted, never a simple matter of desire searching for and settling on a satisfying image.

If this is so, we become ourselves and discover our-selves in a process that does indeed involve some frontier-crossing. For our hands to point towards Jesus, we have to have been sufficiently moved out of our usual ways of thought and action to want to say, 'Don't look at me, look at him.' I no longer want to be what people are looking at, aware as I am of my con-fusion and failure. When I encounter such failure in my experience, I am challenged deeply about my habitual longing to be in control and at the centre; I have to move out from the centre that is my self-image and, in my action, in my body, mark out a path towards truth. If in my failure I have discovered the faithfulness of God through Jesus, I shall want to make clear that this truth is found in him. My recogni-tion that I have failed, my giving up my would-be per-fect self-picture, becomes a pathway to Christ for someone else.

But God has crossed the frontiers of divine life. God is not content for me to say only, 'Forget me, I don't matter', because God's attentive love looks to me, assuring me that he is, to adapt the scriptural phrase, 'not ashamed to be called my God', not ashamed to be who he is and to be identified as who he is in relation to me, even though I am a mess. Throughout the biblical story, God accepts identification in terms of those he works with — the God of Abraham, Isaac and Jacob, the Lord God of Israel, the one whose 'body' is the community of Christian believers. There is no safe and pure self-identification for God except the mysterious affirmation of the divine freedom to be identified as the God who chooses a recalcitrant and mutinous people ('I will be what I will be', as Exodus 3:13 is best translated). So, as we are moved to say, 'Look away from me to Christ, or to God', he says, 'But *I* am free to go on looking to you.' I discover myself as someone who is being made real by his attention to me; I live because he looks to me.

Christians have traditionally been unhappy to think of Mary simply as sharing the depth of our usual human sin and failure; and it is surely true that her 'yes' to the angel indicates that, from the beginning, believers have thought her freedom to respond to God's challenge a sign of some extraordinary depth of spiritual integrity. But if we think further about Mary's role, we may see that she is not so remote from our situation as might appear at first. She comes before us at the beginning of the Gospels of Matthew and Luke as a person of intrinsic insignificance in her context — an unmarried woman in an occupied country. She is summoned by God to a role that could only, in that context, have marked her as more intensely a failure and an outcast — a woman with an unexplained pregnancy, an embarrassment to her fiancé. What can she do but point to her son, as if to say, 'only there will

you find how any of this makes sense'? It is her accep-
tance of risk, reproach and scandal that already points
to her son, whose path will be the same road of rejec-
tion; and in his acceptance of that road, he looks back
to Mary, as if to tell us that she had pointed in the right
direction. Her self-forgetfulness in accepting God's call
is the foreshadowing of the cross. She loves in advance
the love that Jesus will exhibit in life and death; in the
cross, Jesus demonstrates that he loves the love his
mother exhibited in accepting the shame and scandal
of his birth. He is not ashamed to be known as her
son, and in his affirmation of her he affirms what is the
nature of the faith we are all called to.

Mary lets go of safety and reputation because of the
compelling call of God, God's pressure to make himself
real in the world. For most of us — although there are,
thank God, those who will show such self-forgetting —

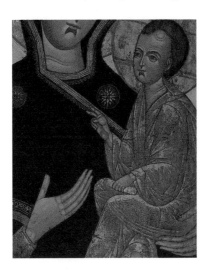

letting go of safety and reputation is the more prosaic effect of coming up against our own weakness and falli- bility. But whether the letting go is positive or nega- tive, it happens, and its result is the gesture towards Christ that stands at the centre of this icon. Only in relation to Jesus will any of this make sense, and I am not in much of a position to guess what that sense might look like; yet, as my life points in this way to

him, I do actually and concretely show him, and he is
alive in me and claiming and affirming what I am.

The boundary to be crossed is that of my picture of
myself, secured in the affirmation of other people or
society at large, reinforced by my sense of control over
the environment I live in. I can cross it by my choice
— as Mary and her son do; or I can be unceremoni-
ously bundled over it by the realities of my life. If the
latter happens, I may want to deny it and retreat; but
the image before us of Mary pointing the way reminds
me that I can do that only at the cost of truth and, ulti-
mately, of any life that matters. I shall become who I
am in God's eyes when I am able to say that sense will
be made only in relation to the one I point to, not by
my success and sanctity. And the sense Christ makes is
not in his masterly reorganization of the world, his
provision of explanations and programmes, but in his

comprehensive loving, forgiving attention to the world that has somehow brought him to birth.

As we look at this icon, then, there is a double challenge. Can I acknowledge all those things that remind me how I fail to be in charge of my world, despite all my efforts? And can I love the love that sees yet survives such failure? If I can, this icon may become an image of myself as I am in Christ. It is not that I become a sort of abstract sign pointing to him, a wooden post in the landscape marked 'This way to Jesus'. The love of a love that does not depend on success and control draws the eye back to a particular human face that can now speak of God simply by being what it is, with all its peculiarities. If the love that affirms and transfigures me has no need of my anxious performance, *I* have no need to hide my face. If God is not ashamed to be my God, I need not be

ashamed to show my face. Thus Mary's eyes look out at me directly, inviting me likewise to show my face to others, that face I return to at the end of the journey that is mapped for me by the icon.

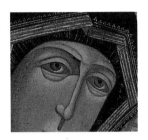

The Virgin
of Loving Kindness

THE *ELEOUSA*

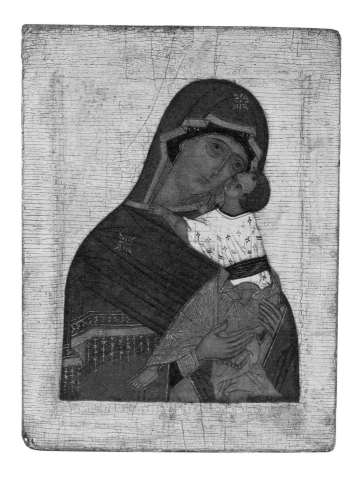

The *Eleousa* pattern is best known to Westerners through the great twelfth-century icon of the 'Mother of God of Vladimir': the child Christ embraces Mary, cheek to cheek, his arm encircles her neck, one foot is thrust towards us as if he is pushing himself up against her body with great energy, and his right hand grasps the corner of her veil. In some later versions, especially in Russia, he has one hand fondling her chin. Somewhere in the background of this image is the text from the Song of Songs (2:6) — 'his left hand is beneath my head, and with his right hand he embraces me'.

As in the *Hodegetria* icon, Christ's eyes are fixed on Mary and hers look out at us (though some of the later 'Loving Kindness' images seem to show Mary returning her son's gaze); and her left hand gestures towards him. Once again, she is showing us something about Christ; but this time, it is impossible to miss or mistake the fact that we are not simply being told something about the movement of pattern of love, as in the first icon we looked at, but are being shown the intensity and immediacy of that love, its unselfconscious eagerness. What is challenged here is much of our thinking about the relation between God's mercy and our initiative in repentance, and in this sense the *Eleousa* icon goes further than the *Hodegetria*.

If we begin, as most of us tend to, with a notion that God stands at a distance waiting for us to make a

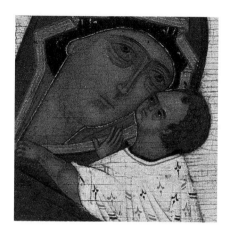

move in his direction, this image should give us something of a shock. The Lord here does not wait, impassive, as we babble on about our shame and penitence, trying to persuade him that we are worth forgiving. His love is instead that of an eager and rather boisterous child, scrambling up on his mother's lap, seizing handfuls of her clothing and nuzzling his face against hers, with that extraordinary hunger for sheer physical closeness that children will show with loving parents.

Instead of the effort to bridge the enormous gap between here and there, between God and my sinful self, we have a movement — direct, intimate, overwhelming, even embarrassing — from God to us. Just as we might want to say to a child, 'Calm down', as it pushes at us or grabs clothes and hair, so we can imagine Mary in this image half-embarrassed by the urgency and overexcitement of the child. Behind the stately postures of the icon, we can see something intensely, untidily human.

This is a child who cannot bear to be separated from his mother. We have seen that God is not ashamed to be our God, to be identified as the one who is involved with us; here, though, it is as if he is not merely unashamed but positively *shameless* in his eagerness, longing to embrace and be embraced. It is not simply that God will deign not to mind our company: rather he is passionate for it. The image of God's action we are presented with here is of a hungry love.

And yes, that does raise some theological issues. Traditional Christian theology has always held that God needs nothing, and that therefore God does not love us because he needs to, because we can offer him something he has not got. Creation exists because of God's pure and unconditional gift, not because God was somehow incomplete without the world, without us. It would be a fantastic illusion, a terrible corporate

self-deception, to think that we are necessary to God's happiness.

This is, I think, importantly true. But if we go back for a moment to some of what we were thinking about in the first of these reflections, perhaps we can make some sense of the threatened contradiction here. God does not need us because of anything in particular about us — because we can solve God's problems(!), because we impress him, because we are successful, powerful, whatever. That would mean that God would be more interested in those human beings who have made a good job of their lives than in the rest of us — and that would run dead contrary to most of what the Gospels have to say. But if God does not need us *for* anything, or even because of anything, we have to say that he simply 'needs' what we are, no more, no less; he 'needs' us to be. And this is not because his own

being is incomplete without us; rather he 'needs' to be himself, to exercise the love that is his eternal life, bringing forth out of his infinite being those fragmentary reflections of its richness that are the lives, the realities, of the created world. He loves the reflection of his love within creation; he cannot bear to be separated from it and goes eagerly in search of it, hungry to find in the created 'other' the reality of his own life and bliss.

So maybe we can make a kind of sense of this image of divine urgency, divine hunger. It is an extreme way of pointing to how God's exhilarated love for divine love itself, within the eternal Trinity, God's joy in being God, diffuses itself and works itself through in the life of what is not God. It is the kind of insight that the Jews expressed in saying that God's 'wisdom' is spread abroad in creation so as to reflect God's joy back to God; or, in later Jewish mysticism, the idea that the divine glory or presence, the *shekhinah*, wanders the earth, a homeless beggar, looking eagerly for souls who will recognize her. Jesus' stories about losing and finding (sheep, coins, rebellious children) centre on the same set of ideas — that God goes looking for us long before (an eternity before) we look for him. It is as if he were looking for himself, for the lost reflection of his own beauty in what he has made.

And here in this icon is a bold 'transcription' of all these themes in terms of a child's eager dependence. This is an image not simply of the Virgin's 'Loving Kindness' but of the love of God in search of us, as unselfconscious and undignified as the clinging child, as undignified as the father in the story of the Prodigal Son running down the road to greet his lost child, an image of the immense freedom of divine love, the freedom to be defenceless and without anxiety. God, we could say, does not care in the least if his love makes him look as if he is dependent on us, as if he needs us: that is our problem, not his.

There is another theme suggested here too in at least some versions of the icon. Mary's gaze turned towards

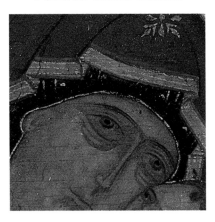

us — especially in the great Vladimir icon — seems sombre, almost tragic, as if she is *burdened* with the knowledge of this love. To be the object of any intense and passionate human love when we do not know how to respond, or do not know *whether* we can respond, is always pretty frightening and sobering. Perhaps that is part of what the icon evokes as well: how shall we bear this unqualified love focused upon us? This may bring to mind the dangerous border between love and terror in the writings of the great

contemplatives like John of the Cross; it may even make us understand a little of what hell might be — the burden of divine love on a self utterly incapable of receiving it. The Bible says that we cannot see God and live — though the New Testament, especially the Gospel and letters of John, and Paul in 2 Corinthians, turns this on its head by saying, 'You *have* seen God and lived, you have seen him in Jesus.'

The terrible weight of divine love has indeed descended on the world in Jesus. Mary carrying the Christ child is carrying what no one can carry. But only those who are beginning to know what the love of God is will begin to feel the fullness of that weight: if Mary looks at us with eyes of grief and care, not only of joy, it is because she is literally first to feel the weight, feel it as the physical drag of pregnancy and the pain of birth-giving. So too any believer who

senses what the love of God does to your 'ordinary perception', your normal care for the self or picturing the self, will know something of what has to be carried. The awareness of divine love as the insistent, energetic wriggling of the child against the parent's body seems at first a touching, domestic picture; only gradually do we know what this insistence means.

God wills not to be separated from us, not to be shut out from any corner of our being. There is a poem by Rilke, 'The Angel', in which the poet warns us against inviting angels into the house, because they will turn the whole place upside down and seek out all the hidden corners and mould us into new shapes. It is something like this that we may sense in looking at this image of invading love, love that does not recognize boundaries. For us, of course, this is a pretty shocking notion; we are rightly taught that love

should not be invasive, should always respect boundaries. But this is a caveat for human relations. In human experience, intrusive or invasive love is an attempt to destroy something, the essential distance between person and person that makes human love a joyful and risky exploration of another's mysteriousness. Trying to annihilate the boundary is trying to get to the end of a process that is not meant to end, trying to consume another and absorb them. There is a sense in which our love for God has to be like this too; there are no short cuts; there is no absolute possession; and we shall never arrive at a point where we have come to 'contain' God. But God's love for us does not face that kind of boundary, since God is not in any way another individual in competition with us. God simply *is* present to every aspect of our being because he is its source and sustaining energy. Recognizing and welcoming that presence as unqualified love is a hard and frightening task, since we are all too easily inclined to treat it as if it were indeed the intrusion of another

individual subject like ourselves. But we need to let ourselves hear the good news that Jesus again and again reinforces in the gospel — that God does not compete, that God's love is without cause or condition, that God is gloriously different from all our assumptions about how human individuals live and negotiate together.

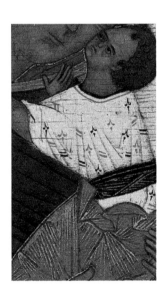

We are right then, in one way, to be apprehensive about welcoming this love, because, like Rilke's dangerous angel, it will turn things upside down; it will confront our assumptions about conditional love and conventional justice; it will oblige us to see God as unutterably, intimately close to the persons we consider least deserving or most threatening as well as to ourselves. The problem with me or with any other fearful and self-protecting human individual is not a matter of somehow crossing the huge divide that we think separates us from God, but dealing with the barriers we erect — bizarrely — against what is actually most immediate to us, what is, in Augustine's words, 'more intimate to me than I am to myself'. It is not that I have a long journey to undertake in order to get to God, but that I have a long journey to my own reality. It is my heart, the centre or source of my own being, that is furthest away from my surface mind and feelings, and pilgrimage is always a travelling to where *I* am.

So the *Eleousa* icon gives us some significant and many-layered messages about the boundaries between people and between God and us. God does not respect the sort of boundaries we take for granted. We say, with some metaphorical extravagance, that God abandons his safety or seclusion so as to be *our* God; we look at the restless, burrowing child pulling at Mary's robes and veil, and recognize that no place in ourselves can be 'safe' from him. We see that the boundary between God and creation is not a line between two bits of territory but the difference between the composer and the symphony, between the cloud and the rain. We recognize that God is equally close to each of us, so that the distance between person and person is dramatically telescoped as a result; yet this generates in us a greater reticence and humility before the mystery of a human other, not an assumption of sameness or a desire to absorb.

Most of all, it should continue to overturn, day after day, the myth of the distant God who needs to be sought out far off and cajoled to come near. God is not merely, like the Prodigal Son's father, on the way to us: he is there at the heart. Or: he travels to meet himself in what is always other, eager to recognize his own joy and beauty in the distinctness of what is not God's self. However we put it — and there are countless ways — God's loving kindness is there ahead of us. Forgiveness is never a matter of persuading God of something but of discovering for myself that there is no distance to be crossed, except that longest journey to that which gives truth and reality to my very self.

Here then, as in the *Hodegetria*, Mary is the sign of our humanity engaged by God. But if the *Hodegetria* is more obviously about Mary as the type of the disciple and witness, here the reference is broadened out: Mary is creation itself embraced by Christ, and more specifically human creation, invaded by Christ and disoriented, disarranged, by his coming. It is hard to speak about this without using that imagery of a kind of divine violence beloved of Augustine and John Donne and others; we need to remember that there is no violence when what we are reflecting upon is simply the burning energy of divine action already in the centre of creation, of what is not God. But the shock of seeing God neither as distant parent nor even as (threatening) adult lover, but rather as hungry child should help to give the whole of our meditation on this image its colouring. God makes us precisely *not* to be God because he loves what is other; yet he loves what is other as if it were God — because the other can only be by the unrestrained outpouring of his own

act of love at the foundation of creation's life. God cannot bear to be separated from us because God cannot be parted from the divine action and the divine joy.

The Virgin
of the Sign

THE ORANS

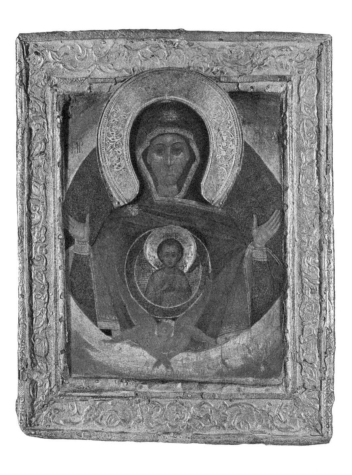

The origins of this image are very ancient. Here is Mary standing and facing us, her hands extended in prayer; and on her breast is a roundel or medallion in which Christ is depicted. The image began its life in the first days of Christianity, when it was not a very good idea to have too many explicitly Christian pictures around if you wanted to avoid being arrested. In the catacombs and in other early Christian contexts, the images are of meals, shepherds, robed teachers — and women, standing, veiled, with hands outstretched in prayer. All of these had meaning for Christians, but gave nothing away. And the meaning of the veiled woman? Since very early on, Christians had imagined the Church in the form of a woman; and the *orans*

figure, the woman praying with hands extended and head covered, stood for the whole believing community considered as Christ's bride.

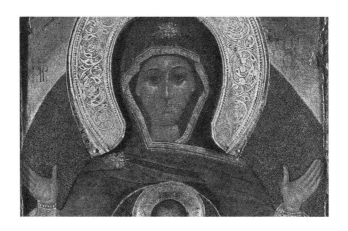

But the icon of the Virgin of the Sign in fact depicts something a good deal more than just the Church as the bride of Christ. Here is Christ praying *in* Mary; Mary becomes, as the Church becomes, a 'sign' in virtue of the action of Christ within her. We are pointed towards one of the most mysterious bits of

our belief in God's coming in flesh among us: for nine months, God was incarnate on earth, God was human, in a completely hidden way, as a foetus growing in Mary's womb. We hear sometimes of the paradox of the newborn Christ child, the Divine Word who cannot speak a literal human word; how much more striking the recognition of the Word growing silently in Mary's body. For that period, the presence of God incarnate in the world was not in visible action or speech, but wholly in secrecy. The Divine Word prays to the Father, loves and adores the Father as throughout eternity the Word must do; and, in the pregnancy of Mary, does so in the human medium of a developing organism not yet active and distinct.

There is plenty here for us to think about in relation to the Church's life. Most obviously, we are reminded of where and what the Church's *essential* life is: the

Church *is*, as Eastern theology has consistently said, the 'divine humanity' of Christ, human nature restored and transfigured by the presence of divine 'energy' saturating yet not destroying it. The Church is the humanity Christ has made possible; its real history is the history of particular persons realizing by the Spirit's gift the new potential for human nature once it has been touched by divine agency, divine freedom, in Christ. At its heart is nothing else, nothing less than Christ's reality, and thus Christ's action — the ceaseless movement towards the Father that is the life of the eternal Son, responding to the outflowing of the Father's life which generates it. That trinitarian pulse is the heartbeat of the Church.

But in practice this means that what the Church does rests always on what Christ is doing; and that includes, above all, prayer. Our prayer in and as the

Church is Christ's life — not something we have thought up, something we perform, we start or stop, but the divine act performed by the Word. What St Paul writes about in Romans 8, the Spirit praying in us, is essentially an account of how the human community expresses its new identity by saying to God what Jesus says ('Abba, Father'). And for the Church to become more and more itself is for it to become more and more aware of this powerful and faithful presence within it.

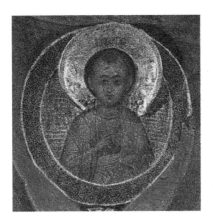

But if we think of the essential hiddenness that the image reminds us of, we must not suppose that being aware of that presence will necessarily make it easier for us to pin down where it is. The strength of the Church will certainly be drawn from those areas of its life where the praying agency of Christ is most active; but we are not all that likely to be able to identify where those areas are to be found. When, occasionally, we have a glimpse, we may be very surprised indeed. What if the life that fuels the Church through prayer is not the routine prayer of the worshipping community, not even the prayer of the religious orders, but moments of exposure and insight, or of desperately needy openness to God on the part of very irregular Christians? Isn't this actually what Jesus' story of the Pharisee and the tax-collector might suggest? What if the Church really lives from the prayer and experience of those it least values in its public talk?

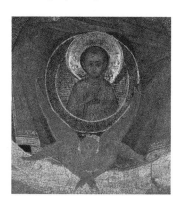

Well, that is a possible implication of taking the hid-
denness of Christ in the Church as seriously as we can
— and perhaps another reminder of God's cavalier
way with boundaries and expectations. But if it is true,
another teasing consequence is that those parts of our
own individual experience that seem least pious or
'together' may be the points at which we are exposed
to God, and so the points from which we most truly
come to live in Christ. Our instinct is almost always to
expect God to work in us at the points where we sense
we are on the right lines, not those areas of our life

where we feel at sea, not understanding, not succeed-
ing, but it may well be that in our honest helplessness
there we come closer to the real well of life than when
we sense all is fairly well.

Jesus is hidden in our lives (as our lives are hidden in
him, our deepest integrity and joy kept from our
greedy eyes by being drowned in his glory), and so
often hidden in our prayer. We would like our prayers
to be a conscious communion with Jesus or the
Father; and time and again the experienced voices of
Christian history tell us that this is not always or even
often the norm. From time to time, we are, so to
speak, allowed a short glimpse of what is really going
on in us; but so fragile are these moments that we dare
not quite rely on them and we cannot photograph
them and pin them on the wall to reassure ourselves.
But whether it is in the lonely dryness of a prayer that

seems to be going nowhere or simply in the frustration of a life that feels as if it is losing direction, God in Christ may be most fully alive. At least our own sense of doing well and satisfying expectations is not getting in the way. And we shall not know any of this while our journey continues, in ourselves or in anyone else. What this teaches us, though, is a proper reluctance to blot out or try to forget any uncomfortable bits of our own lives, or to ignore or dismiss the Christian integrity of anyone else. Who knows where the life is coming through, where the well is rising?

People have often underlined the fact that prayer is less a matter of simply talking to Jesus than of letting Jesus talk to the Father in us. Sometimes it makes sense, certainly, to talk to Jesus, to turn to Jesus as saviour and friend in the most straightforward way; and he is there to hear. But the image of the Virgin of the

Sign recalls us to what the friendship and saving work of Jesus is *for*: it is to bring us into the life that he lives and the prayer he prays. If that means, as it clearly does, that Jesus will not always be a distinct and comforting presence before our eyes, this is not a mark of spiritual failure; we are being taken gradually into the deep mysteriousness of his praying to the Father, a mysteriousness that we can only experience for a lot of the time as darkness and pathless desert. And when we find the hiddenness removed for some instant, it is not to reassure us that we have made a success of things, but to give us a hint of the wealth of Christ's life in us — a kind of momentary overhearing of the Word returning in power to the Father.

Back to the icon for a moment. Mary opens her hands to God in prayer, but her eyes are open to the world. It is not a bad image for our praying. We look without

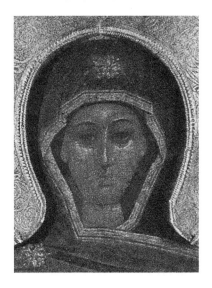

illusion or self-protection at the world, its pain, delight, hunger, grief, hope, and all of that informs, shapes our prayer. Praying is not necessarily best described always as looking towards God; sometimes, and especially in intercession, it is equally a learning to look at the world as if with God's eyes. And in this icon, Mary once again looks at us, not at Jesus: her

prayer for us is in the fact that she so looks — with Jesus in her heart, her womb, she opens her hands to God as she sees us.

If Mary is indeed the image of the true Church, the life that lives under the rather heavy veiling of confusion and failure we are all too familiar with, what we see in the icon of the Virgin of the Sign is a Church that can cope with the hiddenness of God in its life — that is, a Church that does not need constantly to be reassuring itself of its success or even its total purity. It is a Church that understands that it does not always understand what is most important or central in its life — or, in other words, a Church that is not too worried about pinning down where the centre is. It knows that *Christ* is the living centre, and that pretty well all attempts to say much more than this can lead to attempts to tie God down to our criteria of what

works. It is a Church that teaches people to see the world truthfully, to have its eyes open to where real need lies, and also to the real currents of thought and imagination in its own day. And, last but far from least, it is a Church that is suspicious of idolatry, able to stay with the mysteriousness of Christ's presence rather than creating an accessible but false picture to hang on to. Hands open to God, eyes open to the world; and within, the hidden energy that soaks the Church with divine action, divine love. This is the Church that the Virgin of the Sign shows us.

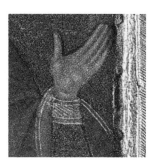

Weaving Scarlet and Purple –
A Legend of Mary

From very early on in Christian history, believers have been just a bit dissatisfied with the fact that the New Testament is rather short on the sort of details we would really like to know about. Many of us feel we need to know all about family histories, the small-scale, gossipy facts. Barely a hundred years after the crucifixion, people were producing stories about Jesus' background to deal with what they thought were the *really* important questions — how did Mary and Joseph meet, who were the Lord's grandparents, what was he like as a little boy, and all the rest of it. Most of these stories are hilariously awful (which just shows us how hard it is to *imagine* the reality of God living a human life, and how astonishingly the Gospels walk

the tightrope of describing this without absurdity and vulgarity); but occasionally they come up with little images that seem to go deeper, and have a rather haunting quality.

Mary, one legend says, was brought up in the Temple precincts (where she was, of course, fed by angels); and, like the other young ladies living in this rather strange boarding school, she was occupied for a lot of her time in weaving the veil of the sanctuary. When they drew lots, she was assigned the weaving of the purple and the scarlet thread, and was sent home to Nazareth to spin. She takes up the scarlet wool; pauses to go to the the well for water and is greeted by Gabriel as she goes. But she sees no one and returns, anxious and flustered, to the spinning wheel. This time, she takes up the purple — and Gabriel stands before her and announces her future.

The associations these pictures set up are almost
unmanageably wide-ranging. We are meant to think of
all those Old Testament stories about meetings at wells
— Isaac and Rebecca, Jacob and Rachel, Moses and
Zipporah; of the angel who shows Hagar the well in
the desert when Abraham has banished her from his
home; of Jesus himself and the woman at Jacob's well
in Samaria. The well is where the great meetings occur
that take forward the history of God's people — as if,
beneath all the changes of history and development,

the bubbling freshness of God is always there, coming up again and again from the depths. But we might think too of Jesus' words to the Samaritan woman in the Fourth Gospel, that the refreshment Jesus gives becomes itself a well of water springing up in the believer's heart, words echoed later in the Gospel (7:38), when he speaks of the streams of living water flowing — literally — from the 'belly' of the believer. Mary stands for all the history of God's people, the steady knowledge of promise and faithfulness; but she is also the first explicit believer in Jesus: from her

womb flows the river of life. And when we echo her 'Yes', the freshness of God in Jesus flows from the centre of our being too.

But there is more, and it is more uncomfortable. Mary is spinning the wool for the sanctuary veil, the curtain that hangs in front of the Holy of Holies and the ark of the covenant, the sign of the unbridgeable gulf between sinful humanity and the holy God. No one goes behind that curtain except the High Priest once a year, to stand before the empty throne of God and make peace between God and his people. But as Mary labours away at this sign of separation, holy fear, she is interrupted at her work; God, you could say, steps through the veil himself. From the sanctuary of heaven, from the terrifying emptiness between the cherubim on the ark, God enters another sanctuary, the holy place of a human body. He parts the curtain

of human fear and guilt; and he is able to do this
because this human creature, this young peasant
woman, is enough of a stranger to fear and guilt to let
him in wholeheartedly. Now when we look at God, we
do not see only the terror and darkness, the cloud that
brooded over Sinai; we see Jesus, taking his throne on
a mother's lap. This is the inmost mystery, the holiest
of holies; and the mystery and, yes, the fear are not
because God is so strange and far away, but because he
has come closer to us than we are to our own selves, as
one of the saints has said.

Sometimes (and there are a good few sermons and
poems about it) Good Friday falls on 25 March, Lady
Day, when we commemorate the Annunciation. Those
generations who knew these legends about Mary at
her spinning wheel will not have missed the strongest
echo of all: the veil of the temple being torn in half as

Jesus gives his last cry from the cross, the sign that he has once and for all passed beyond the veil, as the letter to the Hebrews says, and lives for ever in the sanctuary of heaven. Because he has torn the veil, we can enter with him; we live in the heavenly sanctuary, offering prayer with him. That is what is happening at every Eucharist. So just as Mary is interrupted as she spins the curtain, the whole history of the world is interrupted by the cry of Jesus from the cross; all we try to put between ourselves and God is torn down by God's own utterance.

What do we put there, what curtains do we hang? Shame, perhaps, the false modesty that makes us feel we dare not come directly into God's presence because its light would hurt our eyes and make us feel unbearably, hellishly, inadequate. Custom and convention, treating the curtain as if it were a wall; we have forgotten that there is anything behind it. We carry on, talking about God and ourselves flatly and boringly, as if there were no reality beyond. Sometimes what starts as modesty and understandable anxiety about the holiness of God turns into this dull conventionalism. At the Reformation, our Anglican ancestors were so overcome by the holiness and glory of the Eucharist that they built up elaborate schemes of preparation for it, and increasingly discouraged people from regular communion. Within a generation or two, this had turned for the majority into a thoughtless and dreary

neglect of the sacrament. Nowadays, we might think a bit more holy dread of the sacrament would not do us any harm.

Whatever it is, making and maintaining the curtains involves a fair bit of work. Human beings will put surprising amounts of energy into avoiding the reality of God. And here is the uncomfortable challenge: how much of the energy of the Church and of each one of us is devoted to curtain-making? How resentful are we of being interrupted at our work? In the often tense and politicized atmosphere of our churches, we can get so involved with the curtains that we lose sight of the sanctuary, of Jesus enthroned between the cherubim, Jesus enthroned on Mary's lap: the utterly astonishing fact of God's glory fully living in a human being, with all the startling effects that has on how we see and understand what it is to be human.

Our convictions may be strong and may involve us in conflict; that cannot be avoided. What can be avoided is letting the spinning (and the spin-doctoring!), the weaving and knotting of our struggles become so tightly drawn a fabric that the hand of God can barely begin to tear it through. In the middle of all the busy life that surrounds the religious sanctuary, we are asked to stop: how much of this, says the Lord, is the product of fear, the desire for power and success, how much is a sort of postponing of the encounter with

God because religion is far easier to manage than God? Stop and sit still; let the living Word of God tear the fabric of your expectations and your anxieties alike, tear through the embroidered pictures on the curtain. It hurts all right; it can break our hearts when the images we have of God and ourselves, images into which we have put so much labour, are challenged by both the silence of God and the humanity of God. But, again and again, we have to go back to this readiness to be judged and exposed by God; to go back to the well of God's freshness where yet another meeting takes place that will move on what God is doing with his people. And, as we should not need reminding, the weaving of religious veils will keep our eyes also from the reality of the world in which God's human images suffer so terribly. The tearing of the veil is so that we may see humanity — including our own humanity — as well as God.

Purple and scarlet: Mary spins the cloth of royal colours for the Temple. The angel tells her to put the veil aside: the true royalty is the purple and scarlet of the cross. There God shows that he is God by standing aside from all human power, religious and worldly, so that by his death we may be recreated as if from nothing. The invitation of God is spoken; the veil is torn as Mary says 'yes'. The word becomes flesh in that moment, and Good Friday and Easter are already there. Now as we stand beyond the veil, with Christ in the heavenly places, we have begun again to say 'yes'; and we must day by day go on stilling our hearts so that they can fully hear and receive the cry from the cross telling us that all we use to keep God away from us is futile in the face of his royal freedom, the freedom to be God with us.

Epilogue

When we return from a pilgrimage, we should be bringing with us something of the God who has been walking with us on the way. In looking at these images of Mary, we should also have been given something of her — that is, something of how *she* received and carried the God who came to her. Who is the God she encounters? First, the one who has already turned a face towards her, who is there in advance of her response; the one whose loving gaze is what moves us to love — to love ourselves as well as all others that God loves. We learn to look at all human faces with the rather disturbing knowledge that they are faces that God has already looked at, just like our own. We point to the loving gaze as we turn our eyes to the world.

Then, we are aware of the God who will not let go of us, who travels from infinity to be close to us, not waiting for us to reach the foothills of heaven before attending to us. Wonderful but also very frightening indeed: God will not let us hide, because hiding does not allow us to receive all that God wants to give of life and joy — though the receiving of such life and joy may feel utterly disorienting. And when we look at one another, we see not only a face that is being looked at by God, we see a person from whom God cannot bear to be parted; so how can we bear it? Any divisions in our world, class, race, church loyalty, have to be confronted with the painful truth that apparently we find it easier than God does to manage without certain bits of the human creation.

And last, we find the God who has taken up residence in the heart of our humanity, who prays when we are not looking, not trying, who is at work when we are silent or helpless, and who can never be pinned down to a here or there in our individual lives or in the Church at large. All we can do is keep our eyes on the world in its fullness and our hands and hearts open to God, letting God be God in us, through the prayer Jesus prays as he gives us the Spirit. We should be going back from pilgrimage with eyes wider open. Holy places are places where our vision is transfigured — not so much in simply seeing God afresh, but (as always follows from that seeing of God) seeing the world afresh — and ourselves in it. New frontiers have been crossed, not from one bit of the world's territory to another, but from one level of being in the world to another, a deeper belonging with God and creation. What we hope is that those who meet us may see, as we have, Jesus *involved* with us — looking at us, clinging untidily to us, quietly working and speaking in us.

Imagining Mary in words and pictures has always been one of the most powerful ways of imagining the Church, and so of imagining ourselves freshly. May we help others to imagine and to encounter the child of Mary as we go to our business of discipleship.

The illustrations:

The Tichvine Mother of God, Russian, XVIIth century.
Icon Museum, Recklinghausen

The Korsun Mother of God, Russian, XVIth century.
Coll. National Museum, Paris

Our Lady of the Sign, Russian, XVIth century.
Private collection

(Permissions sought)

Scarlet and purple fabric studies by Leigh Hurlock